THE DRAWINGS OF RICHARD UPTON

Richard Upton at Laken Bay (RATHLACKAN) Co. Mayo

THE DRAWINGS OF
RICHARD UPTON

IRELAND AND ITALY

DAVID SHAPIRO

Afterward by ROBERT BOYERS

New
York

Published on the occasion of the exhibition
"The Drawings of Richard Upton: Ireland and Italy,"
under the auspices of <u>Salmagundi</u>, Skidmore College,
Saratoga Springs, New York

Sordoni Art Gallery
Wilkes University *March 2, 1997 — May 4, 1997*

List Gallery
Swarthmore College *September 5, 1997 — September 30, 1997*

Ben Shahn Galleries
William Patterson University *March 16, 1998 — April 17, 1998*

Acknowledgments: This project has been made possible by support in part from the
New York Foundation for the Arts; RCCA: The Arts Center; Skidmore College; and by
the enthusiastic participation of Robert Boyers, Peggy Boyers, Chris and Jeffrey Elgin, Patti Henderer,
Lindsay Shapiro, Sue Stein, Paul Hayes Tucker, and Christine Vitolo.

Library of Congress Catalogue Number: 96-61676
ISBN: 0-9629503-2-7

1500 copies were printed
by Llewellyn & McKane, Inc., Wilkes-Barre, Pennsylvania

Color photographs by Neil McGreevy

Set in the Adobe issue of Monotype Centaur,
a typeface designed in 1915 by Bruce Rogers.

Cover: UNTITLED/BALLINGLEN 1996
 [D96-2]

Frontispiece: Richard Upton at Laken Bay (RATHLACKAN) Co. Mayo
 Photograph by the painter and composer Nancy Wynne-Jones, 1996

CONTENTS

These lines are the paths of Van Gogh's impetuous impulse towards the beloved object.

Nobody's here on the blank mountain.
But listen: human voices, noises.
Brightness falls like shadow into the forest.
Again refracted on blue green black moss.

Wang Wei

LANDSCAPE AS GOD:
THE DRAWINGS OF RICHARD UPTON

David Shapiro

WHAT IS EXTRAORDINARY IN THE ART of Richard Upton is the richness of his art of sensation: the painterliness of his oils and the linear finesse of his great draughtsmanship. The observant eye is evident, as is his commitment to the documentation of interior and exterior factualities. His turbulent drawings have a quality of all-overness that seems an inheritance of Leonardo's Deluge and of Cézanne as much as Pollock. We cannot forget that Upton emerged into his own "voice" in an exigent reformation of the Abstract Expressionists and the pedagogy of Hofmann. Upton's reformation, however, is respectful of antecedents, and he has granted to himself large permissions as well as a series of constraints.

No doubt, the constraints of scale he has worked with and under may be more readily underlined than his permissions. It will be interesting to note that the scale constraints, his decision to work in what seems like intimist scale, actually liberates him to create work of immense and glowing substance and even monumentality. Just as a poet may elect, like Emily Dickinson, to inflect the seemingly small-scale of the hymn, so Upton has elected to investigate the mastery of his particular material limitations. He has discovered, like the Oulippian group in Paris, a group that promulgated the sense of literature as an inquiry into constraints, a new power in drawings that create an epos of pulsating landscape within the seemingly conventionalized margins of his insistent order. His drawing is, thus, always a philosophical-linguistic meditation, it seems to me, on the nature of scale and frame.

Rather than intimism, we have a resolute and brilliant exposition concerning the fateful power of scale itself.

Upton has a funny and Oedipal anecdote of his father remarking about the difficulties of transporting the large early canvasses he had created in young adulthood under the influence of Hofmann, Motherwell and others. This anecdote has a kind of Eriksonian ring to it, a vital negative that left the artist with a beginning and a clearing of an aesthetic debt. The investigations he has pursued, like a little-known group of single pears, reminds me of the return to sonnet, sestina, villanelle, and pantoum by the poet Ashbery at about the same time. Ashbery returned to the seemingly conventionalized spaces of repetitive song-like forms to discover surprises latent within arbitrary rule-systems. Upton could have continued as a student, as it were, of the free streamings of Expressionists, but instead learned to create an art both more troublingly coherent and more reticent in its irregularities and its turbulence. The seemingly expansive American mural-scale was to be replaced by something more Ryder-like in its luminous condensation. If Pound was right that condensation was the very key to an imagistic art, Upton's clear reformation of scale exposes much second-generation Abstract Expressionism as flaccid and overly elevated. He achieves his own democratic vistas through this critique.

I place part of this program of reformation as continuous with a late Romantic-realism out of Constable and his fabulous discoveries of a pantheistic painting of the poetry of earth. The grand factualities in Upton are continuous with the English sense that a "protest on behalf of nature" must be conducted, without contempt, by Negative Capability, that is, the Keatsian ability to enter nature and all things without taking moralistic sides and with the acceptance of probability. This is an art without villains,

without cartoons. It is an art at the furthest remove from Pop and its satires and the carnival of kitsch in our time.

For a long time, I have been intrigued by those few artists in our day who have been able to heal the split between abstraction and figuration. Sometimes, this war or iconomachia has seemed to overwhelm the dogmatists of our day, and reductive sides have been drawn. A true pluralist, like the historian and theoretician Meyer Schapiro, has been rare. Pluralism itself has seemed to some like a plea for mere inclusiveness or complaisant collage or eclecticism. But what Upton's art suggests is that a powerful art can pulverize our categories and lead us to suspect that there has never been an august separation of abstraction and figuration except in dogma. The "landscapes" of Upton are often the most extensive abstract mosaics of seemingly "pure" pattern. On the other hand, his patterns are always already the recoveries of a fascinated empiricism. Why I regard his art as particularly luring and mature is that it offers us the opportunity to be confounded in our usual categories. Here, again, as in his option to remain decisively fixed in size but not scale, he has remained pluralistically wiser than those who choose sides.

The same must be said for the subtle Eros of his works. Here, I would also appeal to that skeptical sense of Eros in which Meyer Schapiro found the tactility and vitality of Cézanne's apples to bear a libidinous weight: personal, restless, and beyond mere symbol-mongering. The Italian and Irish landscapes have been discovered by Upton to carry "secondary" possibilities of the body, of what Schapiro, following Paul Schilder, called "the internality of the body," as it were, the body felt from the inside. These relations are never fixed upon as easy puns, but there is a willingness to seize upon the landscape as it becomes, one might say, anagramatic of the body.

I would celebrate the diversity of these drawings and their developmental zeal, but really what is significant is not a Darwinian mode of growth but an insistent filling out that is a record of maturing. What we witness is the "diaristic" sense of drawing as a full record. The drawings are not meant to be preparatory; they are complete and have completion as their thematic and truest <u>topos</u>. Their repleteness is, indeed, the sense of the sublime that a critic such as George Leonard has seen in a line extending from Wordsworth to John Cage: a pantheism in which art itself is second only to Nature. The ecstatic ecologism, however, of much contemporary Romanticism is tempered in an art that also prudently and constantly reminds itself by self-reflexiveness of its own nature. Ruskin said saving a bird's nest was better than all art, and his pages are indeed turbulent with this seemingly false dichotomy. In Upton, the refined and refining sense that observation and abstraction are "natural" processes creates an unconfining elaboration out of this old maze. His drawings, sometimes as happily decorative as a Matisse, and at others as melancholy and morose as a Johns, are indications that he has chosen a route away from contemporary agit-prop, in which Nature is Victim or Medicine. He is not a "landscape pornographer" in the bleak phraseology of the sculptor Joel Fisher. The drawings are refreshingly unsentimental or non-sentimental for all their willingness to expose feeling as fact.

I would add, that in many of the darkest drawings there is even the truth-telling sense that Nature is a divinity as filled with *terribilità* as with balm. The Piranesi-like darkness of some of the drawings reminds me that we must be willing to confront the terrifying in Nature. Like the great series of questions in the Book of Job, these are drawings that are not modest assertions of observations but startled records of a mysticity.

We are not used to this in contemporary landscape work, which is often a healing

pastorale of urban folk nostalgic for a Golden Age. To see Nature as a teeming framework of desire is a Spinozist accomplishment. (It is interesting to note that the critic Schapiro himself took as a summer project for his whole life the investigation of small-size large-scale drawing and painting. Some might think this the modesty of an amateur. But it seems to me, as with Upton, the resolute decision of a philosopher of form.) Nature in Spinoza is a God, the only God, and in Upton, this deity is given a local habitation and a name. I have spoken elsewhere of the American tradition of darkness, our transcendentalist line turned negative, as in Ryder, Johns, Bill Jensen, aspects of Marden. In this strange and persistent tradition of opacity and riddles, some of the puzzling strength and criticality of Upton's work may be found. He has found abiding value in the broken surface of things and unbroken observation of such fissures, and thus his drawings are Expressionist in the larger and truest sense that there is no art without addresser and "slipped away" addressee.

No one should suppose that Upton is not a master of the figure, as I discovered in looking at the charming, perfectly seductive, and Diebenkorn-like early drawings of women. These are large statements of control, glamour, and vitality and achieve a compositional directness without embarrassment or false nuance. I would also like to add that Upton is a master print-maker, and his woodcut in six colors of the Italian landscape riven by gigantic lightning in the unusual, for him, format of 18" x 24" is a wild work of expressive ferocity in an unsoftened Nature. The lightning pours down like a twister, and drastic diagonals scour the sky out of an Americanized Hiroshige. The tempestuousness of this piece should banish any misguided idea that Upton is merely an intimist or silent symbolist intent on miniaturization. This glowing woodblock demonstrates the honest forthrightness of the artist and his Cézannism in the largest sense: the paradoxical desire to

present sensation and the geometries of art at the same time. All his early work seems like a correct and correcting meditation to prepare for work that is both Poussinist in its constraints and robustly truth-telling, as in his plunging embrace of the storm. Moreover, the storm should remind us that the artist is exactly a late Romantic who sees "beauty as the beginning of terror" rather than an intimist who shirks the disruptions of the sublime.

Part of the grandeur of these drawings lies in what Upton has called, in conversation with the author, "a longing for something you aren't," in the grand embrace of heaven and earth, the essential binary structure of Upton's landscapes. In an Italian landscape (D95-4) this embrace seems a mystical unity, and it is difficult to decide whether one is witnessing the sky dancing upon a curvilinear and undulant earth, or an earth planted and architectural almost without sky. The confusions are perhaps an indication of how drawing can be both observant and incommensurate with any linguistic category. The artist has said that he accepts the possibilities in quantum mechanics that everything "is moving, everything is space, nothing is still." "Everything moves into everything else and out of everything else . . . What I do is look and try to see as much as I can see and my pencil locates those things that I see and feel." These are the statements of a mystic who travels with his basic syntax, as he has put it, of problems of the window-wall and of deep space, and I think one reason he has been so successful in eroding any local prejudices, for example against Ireland, despite his English parentage, is that he is most devotedly committed to his problematic of notation and space. Much else that is merely local or anecdotal is burnt out, though he has by no means dispensed with description. Actually, it is amazing how much he revels in description, and goes so far as to call his own Irish drawings "stormy" and "in your face" because this is part of his veristic role as a

"recorder." He does not forget the violence of Ireland and its agitated social fate.

But these are, still, the works of a man of peace, who taught at Skidmore College for decades, but is happy with the new life of withdrawal from academic politics — a man who for many years was willing to use a nunnery in Italy as a refuge, a lodging, a base for art and looking. Of course there is nothing pallid in Upton's drawings. We note how much color he achieves throughout his drawings by the careful preparation of ground in mixed media. I see Upton as a constant colorist, and his landscapes (D96-3) are carefully calculated as calibrations in gray and black on a radiant and painterly ground. After one knows his drawings well, one begins to see, moreover, its radical consequences on his seemingly non-linear painting, where, however, drawing becomes almost the central pathway. In a way, he begins to dissolve the ancient color-line feud by a system that reminds one of the cross-hatchings of Johns or the spills of Pollock. He has created a percussive linear system that can become extremely soft and never lose its vitality.

Do we paint the landscape because we have wounded it and it has almost disappeared? The artist has responded to me that he has "an overwhelming and private relationship to it." He admits to a synaesthetic and kinaesthetic rapport with Nature, and he is reluctant to use it in these works as a way of making bold statements about our relation to or responsibility for the planet. He wants the drawings to express his deep connection to landscape without his making public verbal declarations. I see his best drawings as evidence of his resistance to cliché. The robust tempest of strokes in a Ballinglen landscape (D95-19) exhibits this resistance. The drawing is as intent and lush as any jungle, and the viewer is offered both a vista and an almost crushingly opaque wall of restlessness. This is the powerful paradox of nearness and distance in Upton's best work.

Of course, Upton is an obsessive and perfectionist artist of imperfections. In the debate between Nature and Art, he asserts that he may "complete" Nature and "frame it." He also agrees with Pollock that he IS Nature and is not apart from it. He recalls Hofmann as saying that he carried landscape "within." This energy is within his Ballinglen landscapes. Upton again, as he has indicated in conversation, describes but is also consistently essentializing and abstracting. He admires the truth-telling in Pollock, and his own drawing has an insistent decorative truth-telling, as in his syncopated clouds. He has remarked that Diebenkorn can be as light-filled "and structured as a Piero," and one must find this to be a good description of the light-filled geometrizing of his own delightful scapes, so traditional, seemingly conservative, and yet so acerbically surprising and personalist.

Despite his father's imprecations, he has produced small works that are "awfully big." The 8"x10" "sonnet" of Upton, as in his Ballinglen landscape (D95-25), gives us the huge experience of Unity in a whisper. (Webern was said to have composed a whole novel "in a single sigh.") Upton, who has agreed that he accepted the public scale of New York School art blindly in his youth, here renders the absolute sense of the sublime in the fewest possible tones. Giacometti wanted to see woman at a distance and preserved distance by the tiny image, and Upton has created something small enough for the hand's delight. He wants these drawings to become a personal space, where "edges come and go." He wants to avoid the merely perspectival, and he succeeds. He doesn't want his drawing to be a box-within-a-box or, say, distributions within a box; he seeks "experiential release."

One of his most profound draughtsman's problems is indeed his meditation upon the relativity of distance, nearness, and depth. It is something that makes his Italian sketchbook graphite of 1989 (D89-38) so bafflingly rich and baroque. He teaches us

through this drawing, but as a man massively skeptical of system. He is not searching for Manet-like flatness; he avoids the machinery of Van Gogh; and he seeks a perspective, as Lawrence Gowing has it, as fateful and personal as feeling in Mantegna. He is involved, he has insisted, in air itself, the "sequence of changing information" of vast and little and of the atmosphere in front of the eye. This is the restless universe of Upton's vistas, unruined and without the picturesque. He has said of his landscape that it is a "landscape that knows about deep space and flat space . . . and knows about other kinds of systems . . . but it is also something that opens in every direction as well as closes."

Upton has wanted to make something solid out of the politically correct immediacies of our day. He has returned to a kind of home in these Italian and Irish drawings, with their tense reconciliations. He has confessed that he "longs for order." But he also loves the ephemeral fragility in Cézanne's watercolors and their dissolutions. He sees himself as "continuing the battle" between fragility and order. He doesn't do watercolors, though his monotypes are watery, his oils are calligraphic, and his drawings are painterly. He sees endless polarity and contradiction in Nature and has succeeded in representing this multiplicity.

Upton's drawings, as he has concluded, have no conclusions. He is looking for the greatest variety. He returns to half a dozen "favorite places," but in these favorite sites — this "piece of a mountain" — he discovers multiplicity. Just as, for a time, he woke every morning to eat and then paint a humorous and voluptuous pear, so in recent years he renders a landscape with daily and differing voices. He has created as a mental traveler but without the need for the psychological face. He has discovered the face in landscape. And, I reiterate, he has found the way to paint the psychological portrait of landscape. That is, perhaps, the reason why some of his oils and drawings have the richness of Soutine's

portraits of <u>angst</u>. He hates mere pathos, but I do think he has more of a spiritual diary here than many calculate. He knows this narrative order may emerge on some readings. But he numbers his drawings, rather than yielding them to literary titles, because he wants to leave open a variety of readings.

He doesn't want the diary, "but of course they are a diary." And I like the nonglobal, tentative, essayistic, experimental, vital concerns of this erotic landscape. Paul Hayes Tucker uses the phrase "the nectar of the feminine" to describe this phenomenon but the painter does not want this bodily metaphor to over-define the landscape. Finally, the artist does not "lock in" his landscapes; they remain unlimited. The great vistas of his Cortona works (D95-13) are nothing but precision and illusion, the double blessing of a folded negative, of a landscape that is as insolid as a deluge and reassuring as a glimpse of a home or refuge. They avoid being personal essays of the "me and my dog" variety. They rise to the level of the most dissonant chamber music, in which home — as in Haydn's restless works — is never found, always sought.

New York 1997

Note: The author is grateful to the artist for conversations about his art in August 1996, in his studio at Saratoga Springs, New York. Quotations in the essay are from these recorded and some unrecorded conversations. I have also profited greatly from the stimulating critique and careful documentation of Paul Hayes Tucker in his monograph on Richard Upton's Italian landscape paintings. The Wang Wei quatrain is translated by the author.

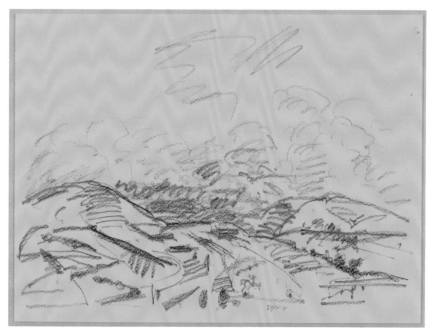

1 Untitled/Cortona, 1987 [D87-10]

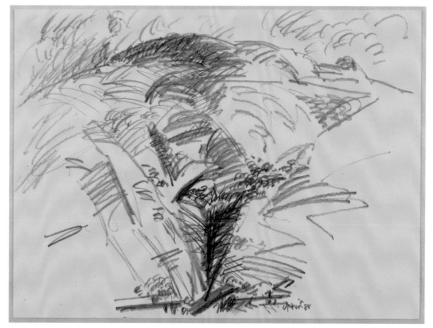

2 Untitled/Cortona, 1988 [D88-20]

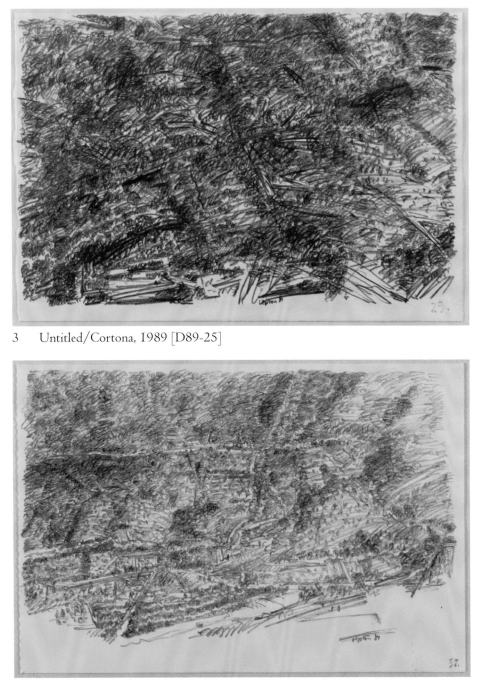

3 Untitled/Cortona, 1989 [D89-25]

4 Untitled/Cortona, 1989 [D89-38]

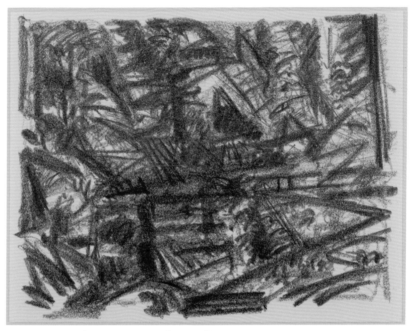

5 Untitled/Cortona, 1990 [D90-5]

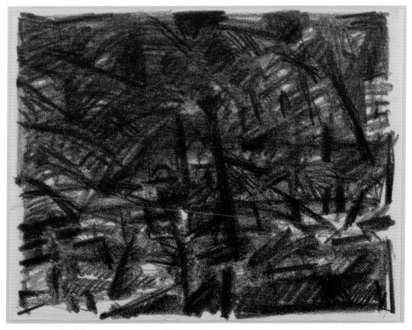

6 Untitled/Cortona, 1990 [D90-6]

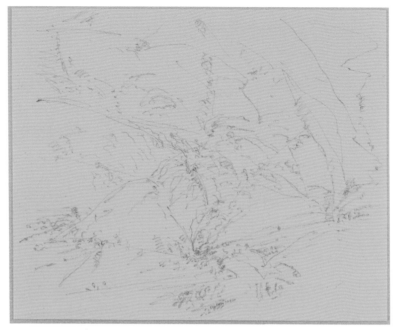

7 Untitled/Cortona, 1992 [D92-2]

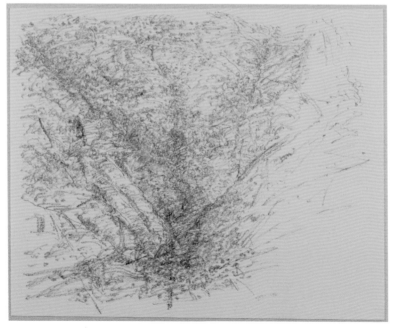

8 Untitled/Cortona, 1992 [D92-5]

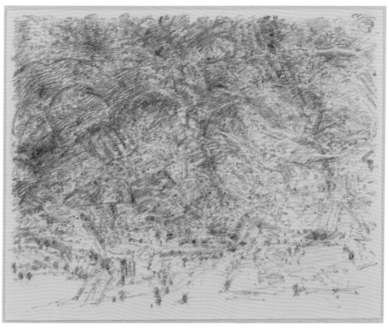

9 Untitled/Cortona, 1992 [D92-10]

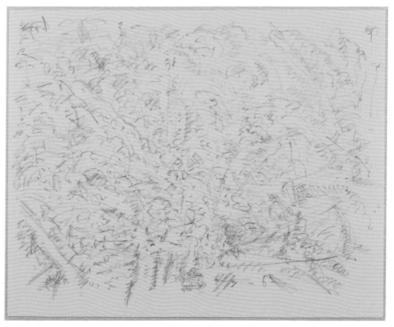

10 Untitled/Cortona, 1992 [D92-12]

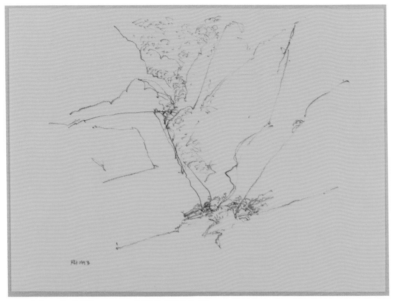

11 Untitled/Cortona, 1993 [D93-3]

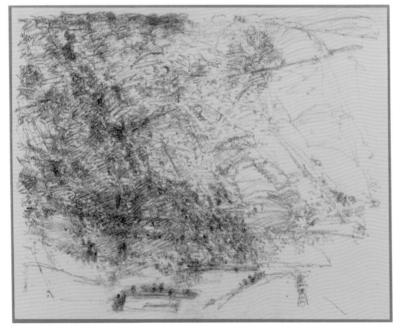

12 Untitled/Cortona, 1993 [D93-4]

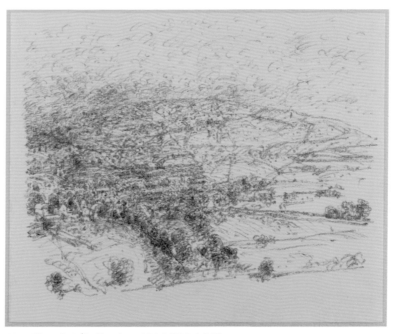

13 Untitled/Ballinglen, 1994 [D94-25]

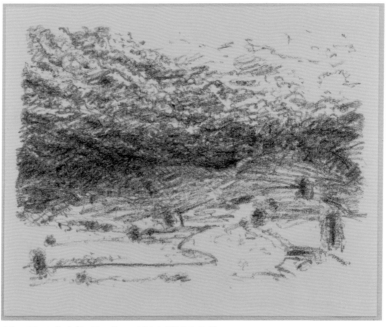

14 Untitled/Ballinglen, 1994 [D94-34]

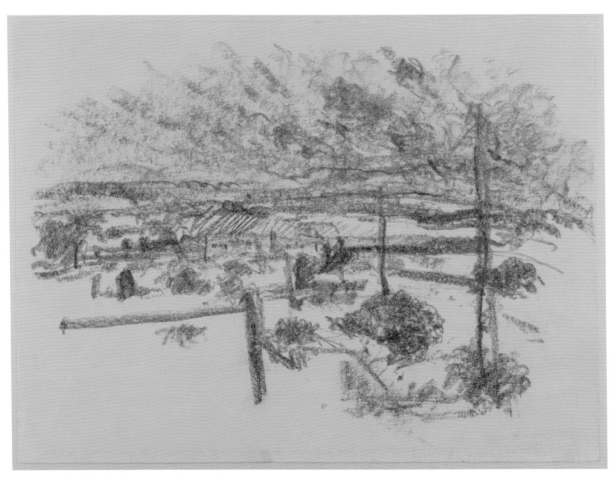

15 Untitled/Ballinglen, 1995 [D95-I]

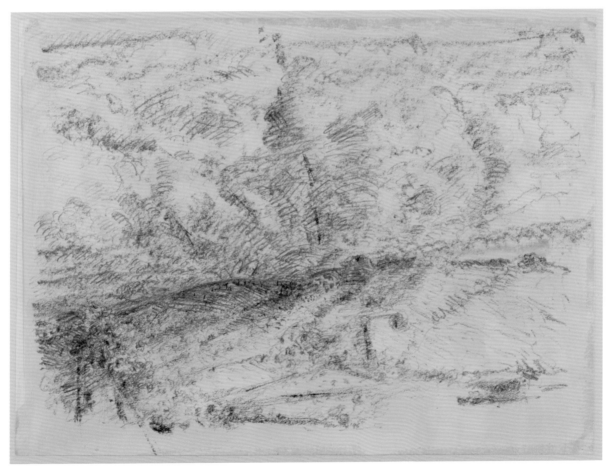

16 Untitled/Ballinglen, 1995 [D95-6]

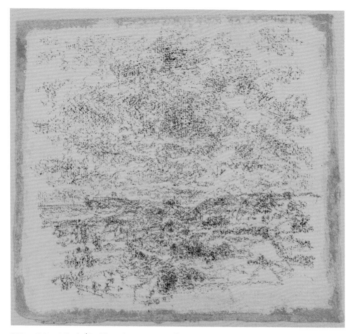

17 Untitled/Ballinglen, 1996 [D96-26]

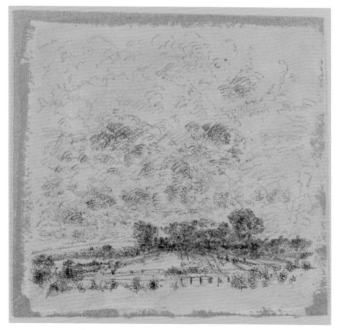

18 Untitled/Ballinglen, 1995 [D95-7]

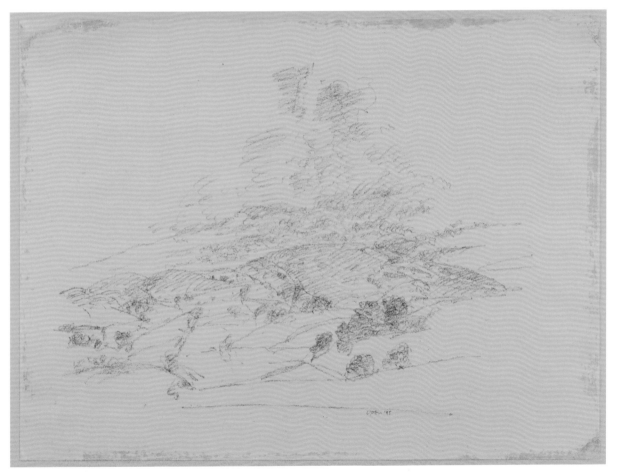

19 Untitled/Ballinglen, 1995 [D95-25]

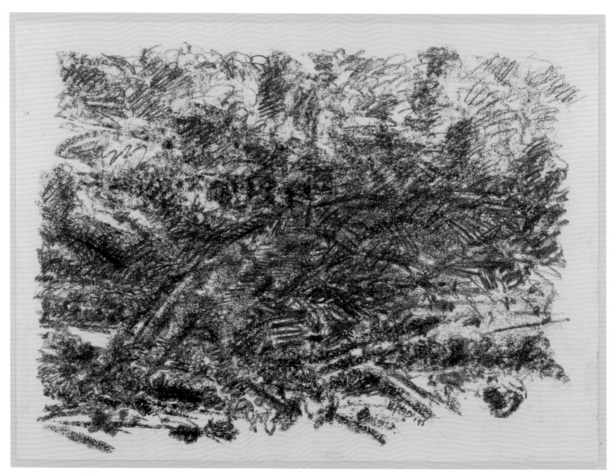

20 Untitled/Ballinglen, 1995 [D95-19]

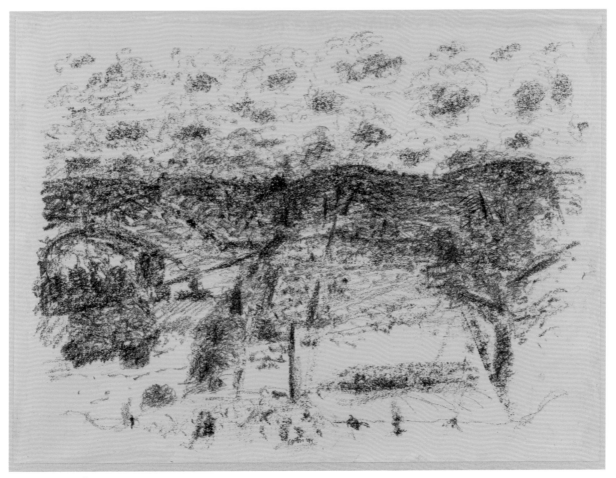

21 Untitled/Ballinglen, 1995 [D95-8]

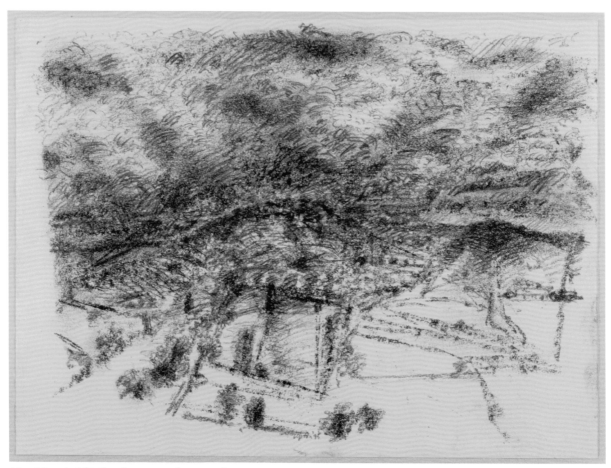

22 Untitled/Ballinglen, 1995 [D95-21]

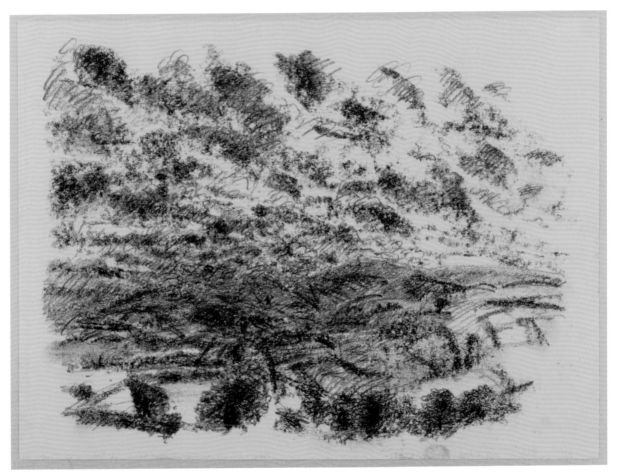

23 Untitled/Ballinglen, 1995 [D95- 24]

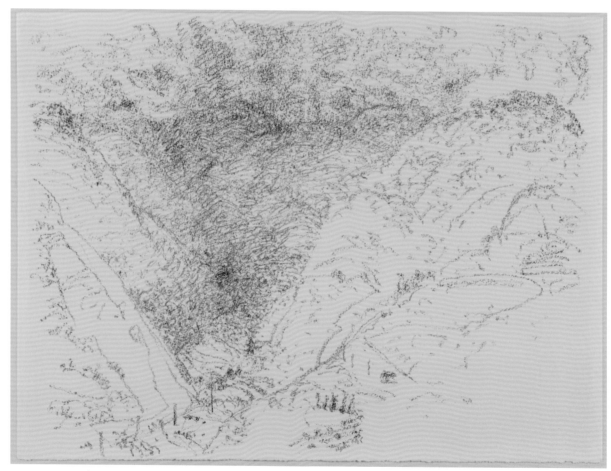

24 Untitled/Cortona, 1995 [D95- 4]

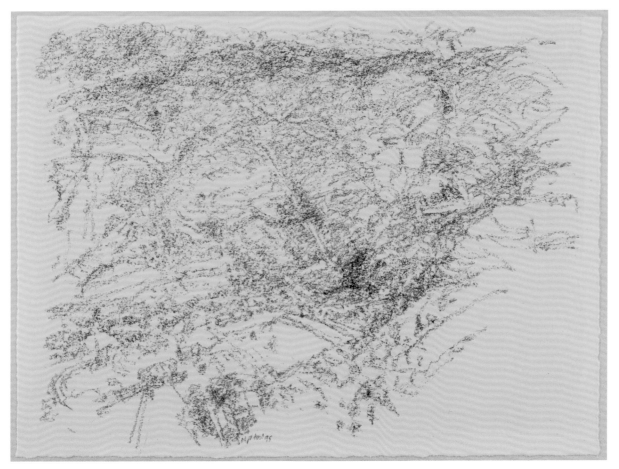

25 Untitled/Cortona, 1995 [D95-I2]

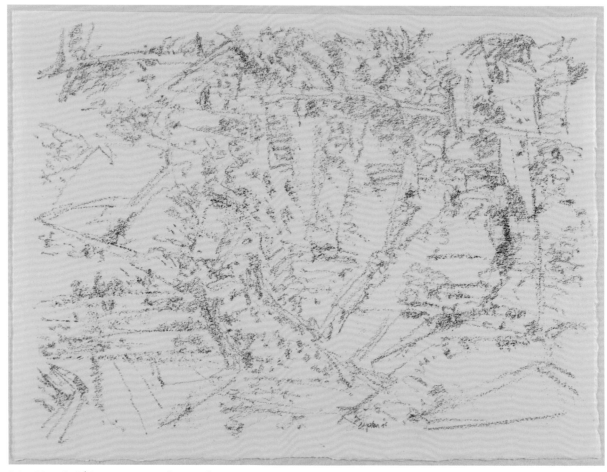

26 Untitled/Cortona, 1995 [D95-6]

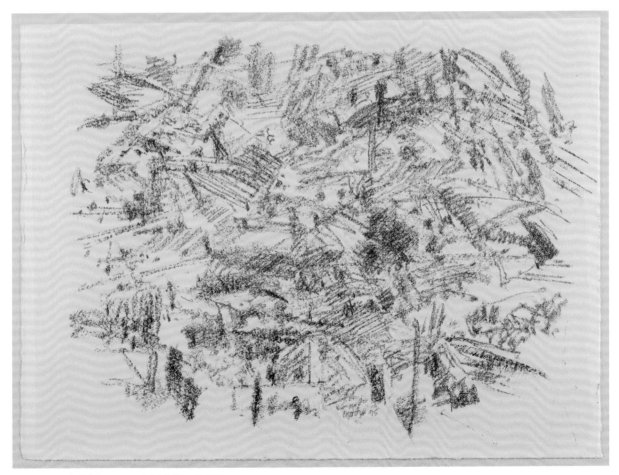

27 Untitled/Cortona, 1995 [D95-13]

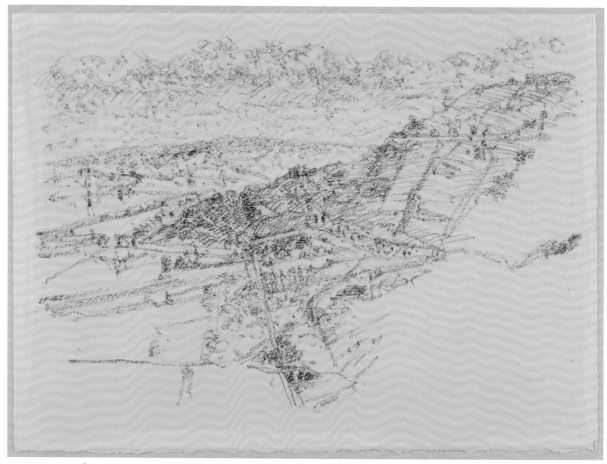

28 Untitled/Cortona, 1995 [D95-14]

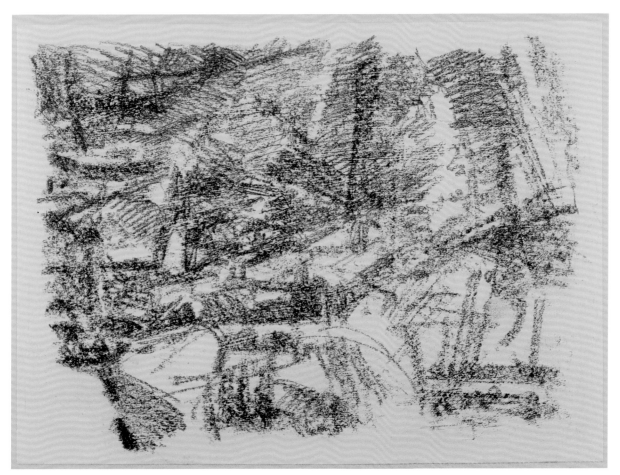

29 Untitled/Cortona, 1995 [D95-18]

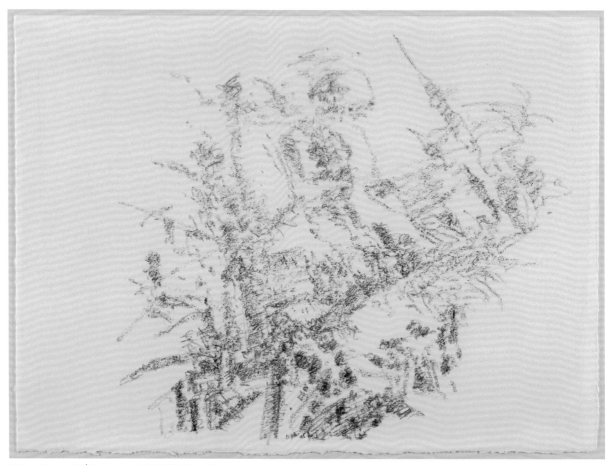

30 Untitled/Cortona, 1995 [D95-28]

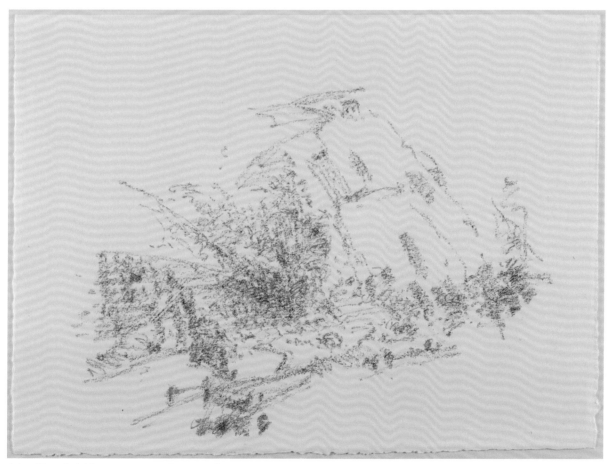

31 Untitled/Cortona, 1995 [D95-29]

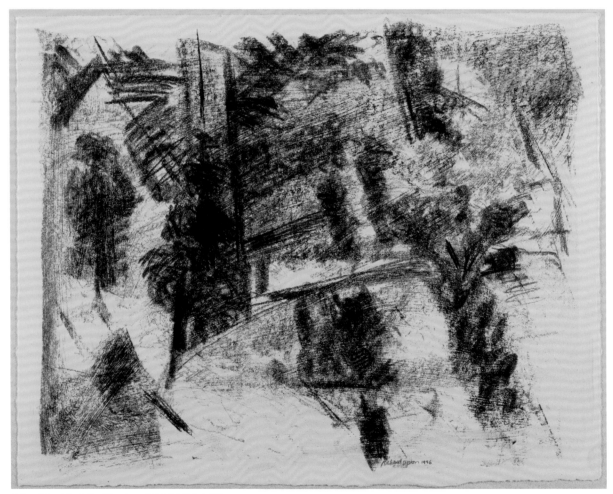

32 Untitled/Ballinglen, 1996 [D96-3]

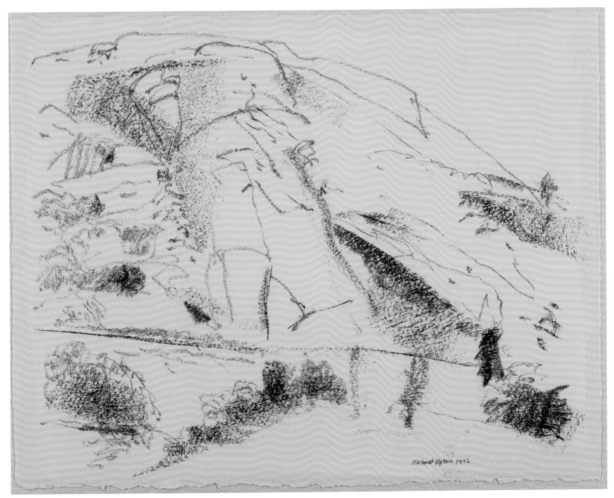

33 Untitled/Ballinglen, 1996 [D96-7]

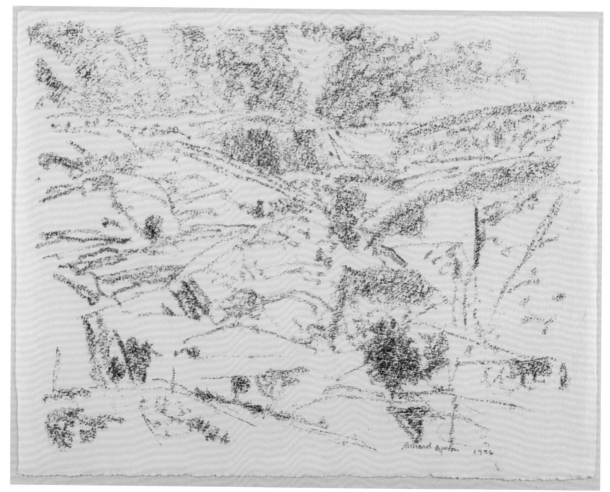

34 Untitled/Ballinglen, 1996 [D96-9]

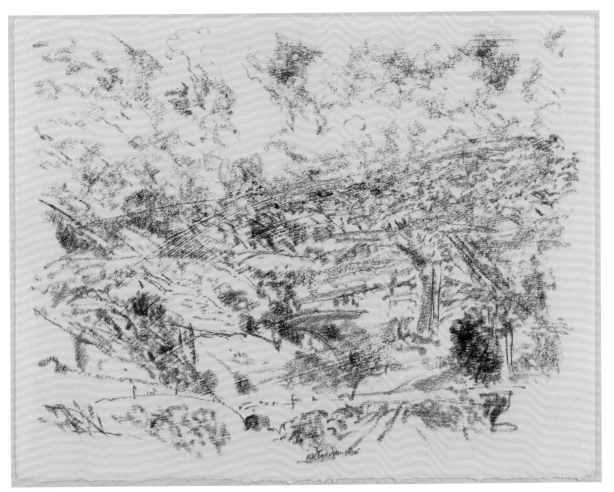

35 Untitled/Ballinglen, 1996 [D96-10]

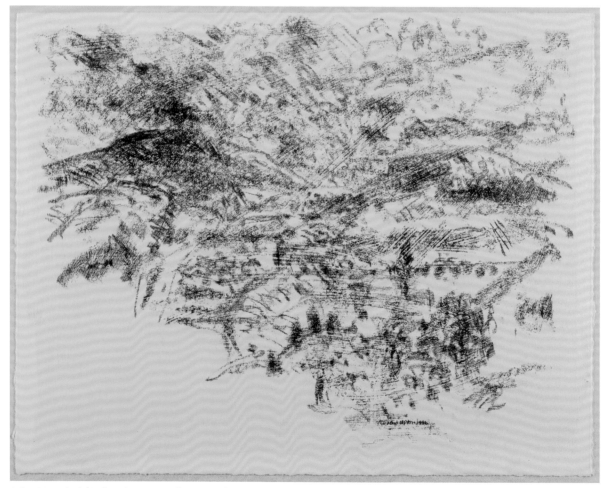

36 Untitled/Ballinglen, 1996 [D96-11]

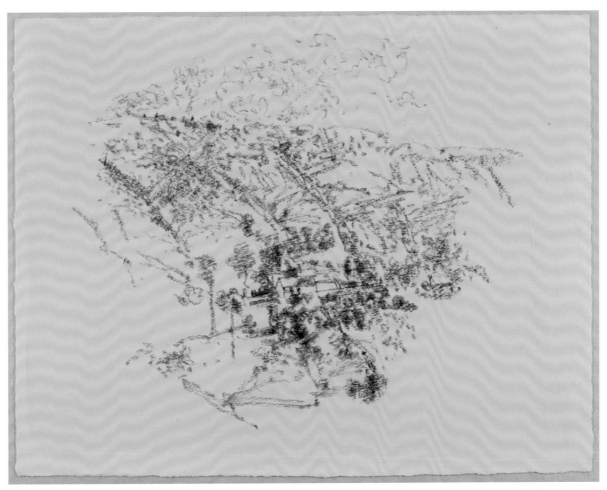

37 Untitled/Ballinglen, 1996 [D96-14]

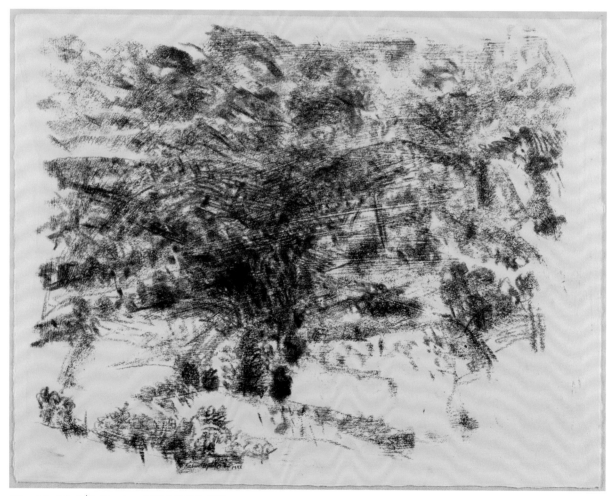

38 Untitled/Ballinglen, 1996 [D96-17]

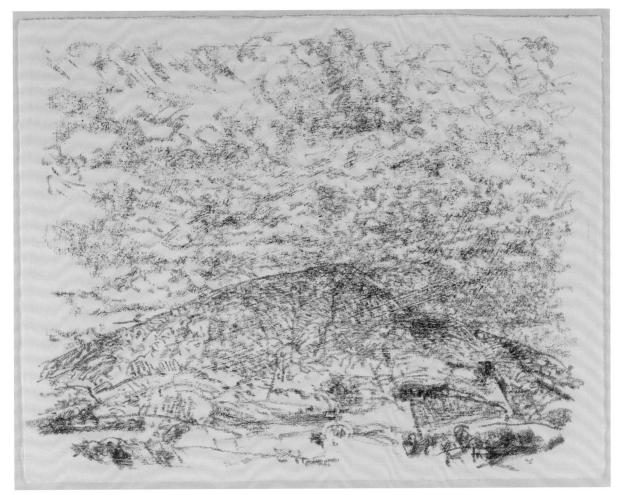

39 Untitled/Ballinglen, 1996 [D96-19]

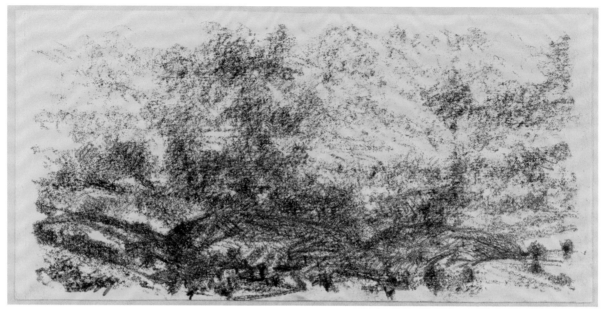

40 Untitled/Ballinglen, 1996 [D96-41]

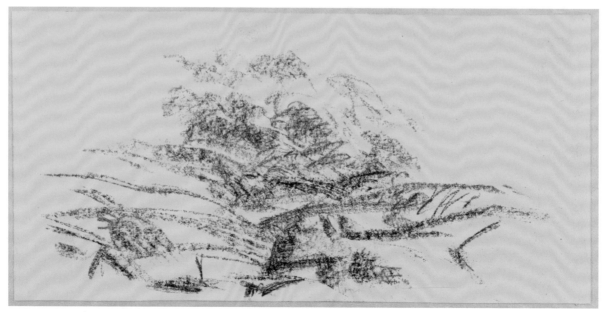

41 Untitled/Ballinglen, 1996 [D96-43]

AFTERWARD
ON LOOKING AT SOME DRAWINGS BY RICHARD UPTON

Robert Boyers

THE CRITIC MICHAEL BRENSON, writing in *The New York Times* some years ago about an exhibition of forty landscape paintings by Richard Upton, noted that "a funny thing happens on the way through this series." The familiar Tuscan hill scenes, with their "quilted fields and bands of cypresses," all instantly recognizable in their splendid umbers and rich olives, their intermittent reliance on sky and light, change before the viewer's eyes into something quite different. "As Mr. Upton moves closer and closer to the landscape," Brenson writes, "his images become less and less recognizable. The last group [of paintings in the series] is nearly abstract," with "thick, lush, sometimes glistening brushwork." In the end, "The pastoral Italy Mr. Upton began with is only dimly present in the memory of his paint."

The landscape drawings of Richard Upton do not typically call to mind paint or the virtues associated with the word painterly, however rich and textured a number of them are. There is usually little in them of the thick or lush. But one does observe on one's way through them a progress resembling the one noted by Michael Brenson and other students of Upton's work. The drawings range from the immediate to the nearly abstract, from the familiar to the provocatively suggestive. What seems in some drawings a concern to capture the solid forms of nature in their precise relations to one another gives way to a more fluid approach emphasizing vagrant gestures and intuitions. What can seem boldly schematic and elegantly meticulous in certain works disappears entirely in works that are obviously more difficult to grasp, works in which the objective is to encounter the fleeting sensation of landscape without worrying about exact physical correspondences. In all of Upton's drawings, quite as the critic Paul Tucker noted in his magnificent book on Upton's "rhetoric of landscape," there is "a combination of calculation and intuition, of vision and chance, confidence and naiveté." But it is impossible not to observe that in some of the drawings calculation predominates, while in many others we are transfixed by the drama of change,

the fresh, sometimes aggressive thrusts of an almost naive recklessness.

What we are calling change in the drawings is perhaps a reflection of the viewer's uncertainty as to what precisely is signified in particular marks on the artist's sheet. Does he intend the flurry of fine lines accumulating at the center of an image to suggest the motion of a tree? Do the darkening lines massed near the top of a page suggest something about the horizon line in the composition or do they represent the artist's furious determination to convey an impression of moody impatience? Do the occasional, intermittently discernible landscape forms trapped within an otherwise seething and indeterminate massing of dark, thrusting lines truly signify there the roof of a building, there a sinuous wall dividing one field from another? In the end, as a matter of fact, we become less and less impatient to resolve our uncertainties. The more we look, the more are we content simply to note the unchartable variation from what David Shapiro calls "figuration" to abstraction. Shapiro commends, in this regard, Upton's wise pluralism, and surely he is right to do so. But we might also, and more sharply, commend what Shapiro calls "the 'diaristic' sense of drawing as a full record."

And wherein lies this fullness? It has to do with the communicated sense that Upton has opened himself to an extraordinary range of moods, each inspired in a way we can observe by his engagement with landscape. We look at Upton's drawings and we see vision briefly working its way through something out there, working its way through just long enough and tentatively enough to feel that a transaction has occurred, that the residue of a feeling will remain, and that the movement on to the next encounter, and the next, will deepen the responsive faculties of artist and onlooker. To look at each one of Upton's drawings, slowly and apart, is to feel that one is preparing for the next, that the restless though loving intelligence shaping the image has just sprung back, as if from sudden sight, and is gathering its force for yet another foray into landscape. There is a more conventional fullness in some of Upton's landscapes, the fullness of something bounded and controlled and sensitively evoked. But the fullness that most moves us and enthralls is the fullness that is indistinguishable from the recording of secret thoughts, the pushing past clarities, the pressure, deft but insistent, to record what the poet Jorie Graham describes as "the instant writhing into a shape, the two wedded, the readiness and the instant." There are other versions of landscape, to be sure, but none that I know more scintillant and refined.

LIST OF ILLUSTRATIONS

All dimensions refer to image size in inches, height before width. Paper size varies. The drawings from 1987 through 1994 are graphite on paper. All of the drawings from 1995 through 1996 are graphite with gesso, gouache and watercolor.

22 Untitled/Ballinglen
 1995
 [D95-21] 8 x 11

23 Untitled/Ballinglen
 1995
 [D95- 24] 8 x 11

24 Untitled/Cortona
 1995
 [D95- 4] 8 x 11

25 Untitled/Cortona
 1995
 [D95-12] 8 x 11

26 Untitled/Cortona
 1995
 [D95-6] 8 x 11

27 Untitled/Cortona
 1995
 [D95-13] 8x11

28 Untitled/Cortona
 1995
 [D95-14] 8 x 11

29 Untitled/Cortona
 1995
 [D95-18] 8 x 11

30 Untitled/Cortona
 1995
 [D95-28] 8 x 11

31 Untitled/Cortona
 1995
 [D95-29] 8 x 11

32 Untitled/Ballinglen
 1996
 [D96-3] 8.5 x 11

33 Untitled/Ballinglen
 1996
 [D96-7] 8.5 x 11

34 Untitled/Ballinglen
 1996
 [D96-9] 8.5 x 11

35 Untitled/Ballinglen
 1996
 [D96-10] 8.5 x 11

36 Untitled/Ballinglen
 1996
 [D96-11] 8.5 x 11

37 Untitled/Ballinglen
 1996
 [D96-14] 8.5 x 11

38 Untitled/Ballinglen
 1996
 [D96-17] 8.5 x 11

39 Untitled/Ballinglen
 1996
 [D96-19] 8.5 x 11

40 Untitled/Ballinglen
 1996
 [D96-41] 5.25 x 11

41 Untitled/Ballinglen
 1996
 [D96-43] 5.25 x 11

42 Untitled/Ballinglen
 1996 (cover)
 [D96-2] 8.5 x 11

RICHARD UPTON

Born: Hartford, Connecticut, 1931
Resides: Saratoga Springs, New York

SELECTED EXHIBITIONS

1998
Ben Shahn Galleries, William Patterson University,
 Wayne, New Jersey
"The Drawings of Richard Upton: Ireland & Italy"

1997
List Gallery, Swarthmore College, Swarthmore, Pennsylvania
"Richard Upton Drawings-Paintings: Ireland and Italy"

National Academy of Design, New York City
"The Language of Landscape: Paintings & Drawings
from the Collection of the National Academy of Design"

Sordoni Art Gallery, Wilkes University,
 Wilkes-Barre, Pennsylvania
"The Tuscan Landscapes of Richard Upton"

"Richard Upton Drawings: Ireland and Italy"

1996
National Academy of Design, New York City
"Collection Update: Recent Acquisitions"

1995
Condeso/Lawler Gallery, New York City
"Richard Upton: New Paintings"

1994
Philadelphia Art Alliance, Philadelphia, Pennsylvania
"The Artist in Rural Ireland: Images of North Mayo"

1993
James A. Michener Art Museum, Doylestown, Pennsylvania
"Richard Upton: Ten Years of Italian Landscapes"

1992
New Britain Museum of American Art,
 New Britain, Connecticut
"The Italian Landscapes: Richard Upton at Cortona"

1991
Everson Museum of Art, Syracuse, New York
"Tuscany Rediscovered: The Chronicles of Richard Upton"

Krannert Art Museum, Champaign, Illinois
"Richard Upton: Italian Landscapes"

1990
Grey Art Gallery and Study Center,
 New York University, New York City
"Paysage Démoralisé: Landscape at the End of the Century"

1989
Georgia Museum of Art, Athens, Georgia
"City on a Hill: Twenty Years of Artists at Cortona"

SELECTED LITERATURE

American Cultural Center. "Jeunes graveurs Américains." Exhibition brochure, Paris, 1971.

Boyers, Robert. "The Attack on Value in 20th Century Art." *History of European Ideas 11* (1989).

Brenson, Michael. "Review/Art: Defining Nature by Its Battle Scars." *The New York Times* (June 1, 1990).

Candell, Victor. "Thoughts about Richard Upton." Exhibition brochure, Krannert Gallery, Purdue University, West Lafayette, Indiana, 1967.

Chayat, Sherry. "Art: Landscape Artist Avoids Cliché in His Tuscan Chronicles." *Syracuse Herald American* (June 2, 1991).

_____. "Richard Upton/Museum of American Art." *Art News* (November 1992).

Corcoran Gallery of Art. "Delaware Water Gap." Exhibition checklist, 1975.

Csaszar, Tom. "Studioview: Tom Csaszar on Richard Upton." *New Art Examiner* (February 1997).

Dearinger, David. "The Language of Landscape: Paintings and Drawings from the Collection of the National Academy of Design." Exhibition checklist, 1997.

Donohoe, Victoria. "The Arts: Richard Upton's Italian Landscapes Displayed at Michener." *The Philadelphia Inquirer* (January 9, 1994).

Norman R. Eppink Art Gallery, "19th National Invitational Drawing Exhibition" Exhibition Catalogue, Emporia State University, Emporia, Kansas, 1995

Galerie Mansart. "L'estampe contemporaine à la Bibliothèque Nationale." Exhibition checklist, Paris, 1975.

Gaugh, Harry F. "Richard Upton: New Work, New Prints." Exhibition brochure, Denison University, Granville, Ohio, 1971.

Georgia Museum of Art. *City on a Hill: Twenty Years of Artists at Cortona.* Exhibition catalogue, Georgia Museum of Art, Athens, 1989.

Grand, Stanley I., and Fred Licht. "The Tuscan Landscapes of Richard Upton." Exhibition catalogue, Sordoni Art Gallery, Wilkes University, Wilkes-Barre, PA, 1997.

Harding, Ann. "Landscapes for our Time: Upton Revives an Ancient Art." *Saratogian* (August 1991).

Indiana Museum of Art. '25'/ *A Tribute to Henry Radford Hope.* Exhibition catalogue, Indiana Museum of Art, Indiana University, Bloomington, 1966.

Jorgensen Gallery. "Richard Upton: The St. John Paintings." Exhibition Brochure, University of Connecticut, Storrs, 1976.

Joseloff Gallery. "New Editions." Exhibition Brochure, University of Hartford, Hartford, Connecticut, 1970.

Kalamazoo Institute of Art. "Drawings by American Printmakers Invitational." Exhibition brochure, Kalamazoo, Michigan, 1972.

Tirca Karlis Gallery. "Promising Young Painters." Exhibition Checklist, Provincetown, Massachusetts, 1962.

Levy, Joel Corcos, and George F. Kuebler. "Richard Upton/The Salamovka Series." Exhibition catalogue, Oklahoma Art Center, Oklahoma City, 1974.

McGrath Art Gallery. "Richard Upton: The Washington County Paintings." Exhibition Checklist, Bellarmine College, Louisville, Kentucky, 1988.

Minnesota Museum of Art. "American Drawings USA." Exhibition brochure, Minneapolis, 1969.

Moore College of Art. "American Drawings." Exhibition brochure, Philadelphia, Pennsylvania, 1968.

Moser, Joann. *Atelier 17: A 50th Anniversary Retrospective Exhibition.* Exhibition catalogue, Elvehjem Art Center, University of Wisconsin, Madison, 1977.

Musée Denon, "Sept graveurs et sculpteurs de médailles." Exhibition brochure, Chalon-sur-Saône, France, 1973.

Nelson Gallery and Atkins Museums. *Centennial Art Exhibition of Landgrant Colleges.* Exhibition catalogue, Kansas City, Missouri, 1961.

Salmagundi. "Richard Upton, River Road Suite: In Celebration of Stanley Kunitz," 10th Anniversary Issue, Fall 1975-Winter 1976.

_____ . "River Road." Introduction by Robert Boyers. Limited Edition Portfolio: Lithographs and Poems, Co-signed by Stanley Kunitz and Richard Upton, 1975.

Schmeckebier, Laurence. "Portfolios by Richard Upton." Exhibition brochure, Davison Art Center, Wesleyan University, Middletown, Connecticut, 1969.

Shapiro, David, and Robert Boyers. "The Drawings of Richard Upton." Exhibition catalogue, Ben Shahn Galleries, William Patterson University, Wayne, New Jersey; the List Gallery, Swarthmore College, Swarthmore, Pennsylvania; and the Sordoni Art Gallery, Wilkes University, Wilkes-Barre, Pennsylvania,1997.

Silver, Kenneth E. "Richard Upton at the Michener Art Museum." *Art in America* (October 1994).

Sokolowski, Tom. "Paysage Démoralisé: Landscape at the End of the Century." Exhibition brochure, Grey Art Gallery, New York University, 1990.

Sozanski, Edward J. "The Arts: Richard Upton: Ten Years of Italian Landscapes." *The Philadelphia Inquirer* (March 11, 1994).

_____ . "Art: Portrait of the Artist after a Stay in Ireland." *The Philadelphia Inquirer* (October 2, 1994).

Tucker, Paul H. *Richard Upton and the Rhetoric of Landscape.* New York, 1991.

Yager Museum. "Richard Upton: Recent Prints and Paintings on Paper." Exhibition Brochure, Hartwick College, Oneonta, New York, 1972.

Zimmer, William. "Art." *The New York Times* (May 17, 1992).

SELECTED PUBLIC COLLECTIONS

Bibliothèque Nationale, Cabinet des Estampes, Paris

Butler Institute of American Art, Youngstown, Ohio

Indiana University Collection, Bloomington, Indiana

Library of Congress, The Pennell Fund, Washington

Montreal Museum of Fine Art, Montreal

Munson Williams Proctor Institute Museum of Art, Utica, New York

Museum of American Art, The Richard Florsheim Art Fund, New Britain, Connecticut

Museum of Modern Art, New York City

National Academy of Design, New York City

National Museum of American Art, The Smithsonian Institution, Washington

Palacio de Bellas Artes, Sala Internacional Instituto Nacional de Bellas Artes, Mexico City

Rose Art Museum, Brandeis University, Waltham, Massachusetts

Victoria and Albert Museum, London

Jane Voorhes Zimmerli Art Museum, New Brunswick, New Jersey

HONORS AND AWARDS

Academician, National Academy of Design, 1995

Ballinglen Arts Foundation, 1994

Richard A. Florsheim Foundation, 1991

Artists for Environmental Foundation/NEA, 1972-1973

Fulbright Grant, Paris, 1964-1965